Guide to
Native Rock Carvings
of the Northwest Coast
Beth Hill

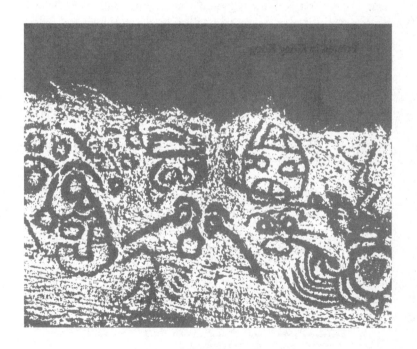

1

ISBN 978-0-88839-737-9
Copyright © 1975,1980 Beth Hill

Printed in 2015

Revised in 2014 adapted from
Guide to Indian Rock Carvings of the Northwest Coast
Beth Hill

Printed in South Korea—PACOM
Production and cover design: J. Chadwick and Max. Chadwick

We acknowledge the financial support of the Government of Canada through the Canada Book Fund for our publishing activities.

Published simultaneously in Canada and the United States by
HANCOCK HOUSE PUBLISHERS LTD.
19313 Zero Avenue, Surrey, BC Canada V3S 9R9
(604) 538-1114 Fax (604) 538-2262
HANCOCK HOUSE PUBLISHERS
1431 Harrison Avenue, Blaine, WA, USA 98230-5005
www.hancockhouse.com sales@hancockhouse.com

Contents

What is a Petroglyph? 5

How is a Petroglyph Made? 6

Where Can You Find Petroglyphs'? 8

Petroglyphs Are Protected by Law 12

What is a "Rubbing"? 14

How Old Are The Petroglyphs'? 16

Why Were the Petroglyphs Carved? 22

The Religion of the First Peoples of the NW 24

Index 47

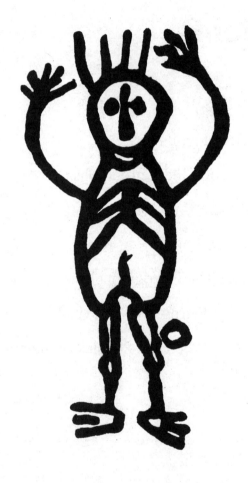

Nanaimo River

What is a Petroglyph?

It is a picture carved into rock. The word petroglyph is derived from two Greek words: "Petros", a stone, and "Glypho", I carve.

The term applies especially to the pictures cut into rock by prehistoric peoples. Petroglyphs are different from Pictographs, which are pictures painted on rocks.

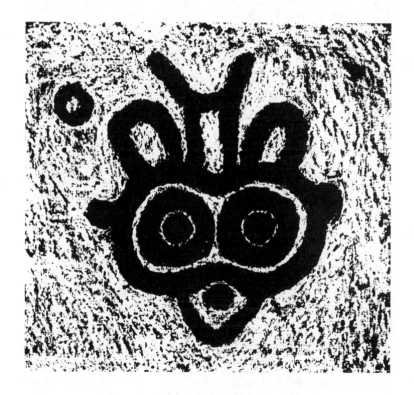

Port Neville

How is a Petroglyph Made?

The petroglyph outside a cave at Pachena Point demonstrates one method of making the designs: using another stone as a hammer, the prehistoric artist has pounded lines made of a series of small holes. In most petroglyphs these holes have then been abraded into smooth grooves.

Pachena Pt.

The first anthropologists at Petroglyph Canyon, on the Columbia River, in 1924 found a hammerstone lying near a rock picture, where the artist had left it. It was a hard green stone conforming at one end to the grip of a hand and worn down at the more pointed end.

The rock of the Strait of Juan de Fuca has hard crystals weathered out in relief, like coarse sandpaper. The petroglyphs of this part of the coast were made by bruising the sharp crystals, so that the lines of the picture are smooth in contrast to the very rough surface of the stone. Because they have not been cut into the stone, such petroglyphs are sometimes very difficult to see at all.

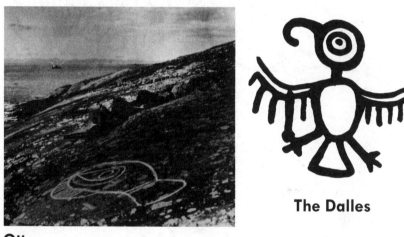

The Dalles

Otter

If the petroglyph were not outlined in chalk it would not be visible in this photograph

Most petroglyphs are cut into sandstone but some are pecked into hard granite boulders. The petroglyph artist used whatever stone he found, but where there was a choice, he used the softer rocks. Most of the carvings are carefully made, but some are crude. Possibly it was the making of the petroglyph which was important, and not the technique; for Christians, the symbol of the Cross has great significance whether it is made of gold and precious jewels or is just two sticks nailed together.

Where Can You Find Petroglyphs?

They are almost everywhere in the world where prehistoric people have lived, the earliest in the caves of France and Spain.

Paleolithic art France

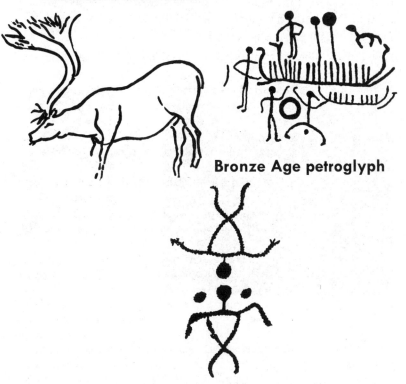

Bronze Age petroglyph

Hawaiian petroglyph

However, the incised pictures of the late Paleolithic peoples of about 20,000 years ago are different in style from the petroglyphs of the Bronze Age, for example, or the Hawaiian petroglyphs, or the Northwest Coast petroglyphs in this book. The carved pictures of our distinct petroglyph style area are found from Kodiak Island, Alaska, to the Columbia River in Oregon.

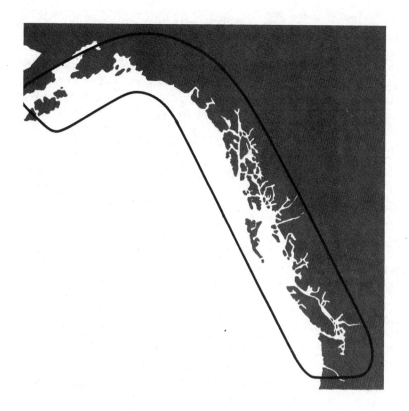

Most of them are at the very edge of the continent, between high and low tide lines, so that they are washed by the Pacific Ocean. Others are on the shores of rivers and lakes near the coast. Although there are several hundred petroglyph sites on the Northwest Coast, they are not easy to find. Many are in remote places, or are covered by drift logs or sand. The easiest petroglyphs to see are the ones at Petroglyph Park, in Nanaimo, and at Sproat Lake Park, near Port Alberni. There is also the Jack Point petroglyph boulder at the Museum in Nanaimo.

Along the Columbia River there are some petroglyph boulders at a museum at The Dalles and a few in the Maryhill Museum above Lake Celilo. Tumwater Falls Park in Olympia has a petroglyph boulder. For most of the rest, you must search the shores. A map of sites won't be too much help in actually locating the carvings.

Alaska

Ground Hog Bay, Glacier Bay

Kodiak Island

Cape Alitak

Baranof Island

Pacific Ocean

Wrangell ●

Etoline Island ●

British Columbia

Observatory Inlet ●

Venn Passage ● Prince Rupert

Douglas Channel ●

Myers Passage

Thorsen Creek ● Elcho Harbour
Tastsquam Creek ● Bella Coola
Return Channel ● Jump Across Creek

Noeick River

Port
Malcolm Island Neville Dogfish Bay
Fort Rupert ● ● ● Cape Mudge Quadra Island

Englishman River ●
Sproat Lake ● Petroglyph Park, Nanaimo
Quisitis Point ● Jack Nanaimo River
Pachena Pt. ● Point ● Kulleet Bay
Clo-oose Otter Pt. ● Fulford Harbour
Helen Point

Agate Point ●
Eneti ● ● Seattle

Olympia ● Washington

Skamania ● Columbia River Oregon
Petroglyph Canyon ● ● The Dalles

11

Petroglyphs are Protected by Law

Since 1960 in British Columbia, petroglyph sites have been protected under the B.C. Archaeological and Historical Sites Protection Act, which sets a maximum penalty of $1,000 fine and six months in jail for anyone who should "destroy, deface or alter an Indian painting or carving on rock". There are similar laws in Alaska and in the State of Washington. In the southern part of the United States where no laws have protected the petroglyphs, carvings have been destroyed by careless and stupid vandalism. Even more effective than the laws, in protecting the carvings, is an awareness of their meaning and a respect for the cultures they represent.

THE GOVERNMENT OF
THE PROVINCE OF BRITISH COLUMBIA

From the

ARCHAEOLOGICAL AND HISTORIC
SITES PROTECTION ACT

PROHIBITIONS

No person or agency shall knowingly

 (a) destroy, desecrate, deface, move, excavate, or alter in any way a designated site or remove from it an object;

 (b) destroy, desecrate, or alter a burial-place or remove from it skeletal remains;

 (c) destroy, deface, or alter an Indian painting or carving on rock;

 (d) destroy, deface, alter, excavate, or dig in an Indian kitchen-midden, shell-heap, house-pit, cave, or other habitation site, or a cairn, mound, fortification or other site or object, situated on Crown lands,

except to the extent and in the manner that he is authorized to do so by a permit.

PENALTIES

A person who contravenes this Act, or a permit or direction of the Minister under this Act, is guilty of an offence and is liable, on summary conviction, to a penalty of not more than one thousand dollars or to imprisonment for a term not exceeding six months, or to both the fine and the imprisonment.

WASHINGTON
Archeological Legislation
Citation. Wash. Rev. Code, Sections 27.44.00 through 27.44.020 (1964); Wash. Rev. Code, Section 27.48.0IO (1964).

Principal Provisions. Willfully removing or injuring a cairn or grave or a glyptic or painted record of any prehistoric tribe is prohibited, unless the record from such shall be destined for exhibit or perpetual preservation in a recognized manner and permission has been granted by the president of the University of Washington or Washington State University or a designated faculty member.

The storage, preservation, and exhibit of (among other things) "artifacts and relics" is declared to be a public project for which public funds may be spent.

Comments. Perhaps this is adequate for what it covers, but it does not cover much.

LAWS OF ALASKA

Source 1971 **Chapter No.**
HCSSB 119 am H 110

AN ACT
Relating to historic preservation.

CHAPTER 35. ALASKA HISTORIC PRESERVATION ACT.
Sec. 41.35.010. DECLARATION OF POLICY. It is the policy of the state to preserve and protect the historic, prehistoric and archeological resources of Alaska from loss, desecration and destruction so that the scientific,historic and cultural heritage embodied in these resources may pass undiminished to future generations. To this end the legislature finds and declares that the historic, prehistoric and archeological resources or the state are properly the subject of concerted and coordinated efforts exercised on behalf of the general welfare of the public in order that these resources may be located, preserved, studied, exhibited and evaluated.

Sec. 41.35.200. UNLAWFUL ACTS. (a) It is unlawful for a person to appropriate, excavate, remove, injure, or destroy without a permit from the commissioner, any historic, prehistoric or archeological resources of the state.

(b) It is unlawful for a person to knowingly possess, sell, buy or transport within the state, or offer to sell, buy or transport within the state, historic, prehistoric or archeological resources taken or acquired in violation of this section or 16 u.s.c. 433.
(c) No person may unlawfully destroy, mutilate, deface, injure, remove or excavate a gravesite or a tomb, monument gravestone or other structure or object at a gravesite even though the gravesite appears to be abandoned, lost or neglected.
(d) An historic, prehistoric or archeological resource which is taken in violation of this section shall be seized by any person designated in sec. 220 of this chapter wherever found and at any time. Objects seized may be disposed of as the commissioner determines by deposit in the proper public depository.
Sec. 41.35.210. PENALTIES A person who violates a provision of this chapter is guilty of a misdemeanor,and upon conviction is punishable by a fine or $1,000,or by imprisonment for not more than six months,or by both.
Sec. 111.35.220. ENFORCEMENT AUTHORITY. The following persons are peace officers of the state and shall enforce this chapter

What is a Rubbing?

Most people think of a "rubbing" as the reproduction of a medieval funereal brass in an ancient English church. To record a petroglyph design we use the same technique, except that we use cloth instead of paper. To make a petroglyph rubbing, stretch a piece of cloth across the carving. Fasten the cloth firmly to the rock with masking tape, then rub black crayon or cobbler's wax (heelball) lightly across the carving.

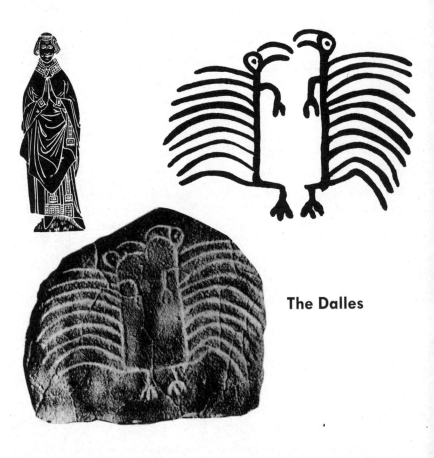

The Dalles

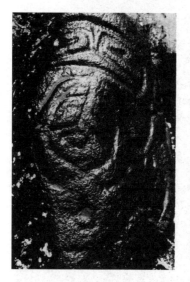

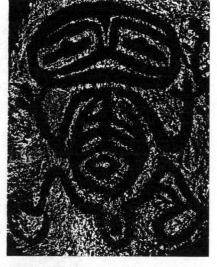

Myers Passage **Myers Passage Rubbing**

The design of the grooved lines underneath will emerge in white on the cloth. To conform with the black-lined petroglyph drawings in this book, the photographs of rubbings have black lines instead of white; this was done by a reversal photographic process. Do not use paint for recording petroglyphs. Crayon is better, and there is no danger of damaging the carvings. Remember that petroglyphs are **protected by law.**

How Old Are The Petroglyphs?

No one knows the age of most of the petroglyphs. We have an approximate age for the carvings at Englishman River near Parksville, because an elderly man now living there reports that his father worked on the construction of the first bridge across the river in 1886, and at that time the deaf-mute artist who had carved the pictures was among the Aboriginals fishing near the bridge

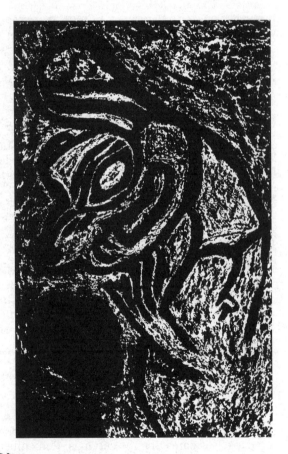

Englishmen River

One of the Fort Rupert petroglyphs on the northern shore of Vancouver Island was made between 1849 and 1882; those are the dates when the Hudson's Bay post at Fort Rupert was established, then abandoned, and during the time of its functioning two white men witnessed a hamatsa ceremony and the pecking of a petroglyph associated with the event

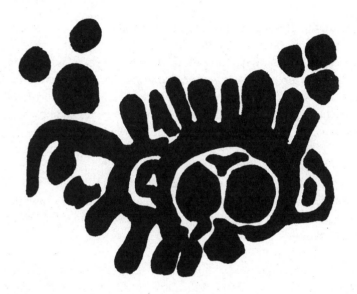

Fort Rupert

The petroglyph of the "Beaver", the first paddlewheel steamer on the northwest coast, must have been carved after 1836, the date of the Beaver's arrival on this coast.

Clo-oose ("Beaver")

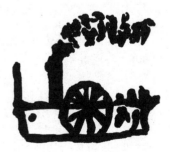

Although we may therefore say that some petroglyphs were made in the 19th century, most rock carvings cannot be dated. The best known tool of the archaeologist, radio carbon analysis, is of no use in dating petroglyphs, for they contain no carbon. And even if there were a method, perhaps geological, of assigning a date to a rock, it would not tell us the date of a depression made in the rock.

It has frequently been suggested that we can estimate the date of the petroglyphs between the tide-lines by the age of old sea levels. The sea has been slowly rising for the past 6,000 years, with a total rise of about six metres. Some people think that it was unreasonable for the ancient carver to work where he would be interrupted by the fluctuating tides. If the petroglyphs were carved above sea level, they say, then they must have been carved before 4000 B.C. However, there are others who think that the petroglyphs were purposely carved where the tides would cover them daily, so that the pictures carry a message to the underwater world of the fish. It is possible that some petroglyphs were meant to call the spawning salmon to come into the streams, where the Aboriginal fishermen could spear and net them.

It has also been suggested that we could at least determine relative age by the degree of erosion of the carvings, the more eroded ones being the oldest. But the general situation is that the lower petroglyphs, being subjected to more washing by the waves, are usually more worn than the carvings which are higher above the sea. The degree of erosion is of no help to us in dating the petroglyphs.

Nor is a change of style useful for this purpose. Some people have thought that the cruder petroglyphs were perhaps older, but one may quite logically argue that the differing styles could have been made on the same day by two different workers, one more competent than the other.

One possible clue to the age of the petroglyphs may be the projections below the mouths of some petroglyph faces, which may be intended to represent labrets. Alternatively, these could be tongues, but some appear to be below the mouth rather than coming out of it. The labret is an ornament of stone, bone, shell or wood which is worn below the mouth, in a hole pierced through the soft flesh.

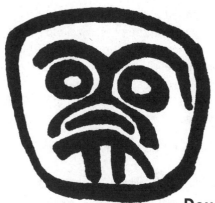

Helen Pt.

Douglas Channel

Anthropologists state that at the time the Europeans arrived on this coast, labrets were not worn by the Coast Salish of the Gulf of Georgia area. Archaeological excavations indicate they were worn from two thousand to beyond three thousand years ago, and a recent excavation at a Gulf Island site produced six labrets, in a variety of shapes and sizes. We may therefore ask whether the petroglyph faces with labret-like projections could be associated with this early period.

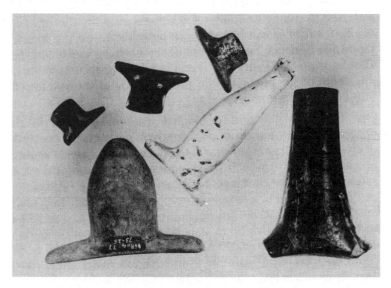

Labrets, Salt Spring Island

The same argument cannot be applied to the Kodiak Island petroglyph faces at the most northerly site on the coast. Some of these petroglyphs have small pits on either side of the upper lip which may be identified as two small labrets because such labrets are known ethnographically in the area. Because these labrets were observed by the first explorers on that part of the coast, the Kodiak petroglyph faces may be fairly recent.

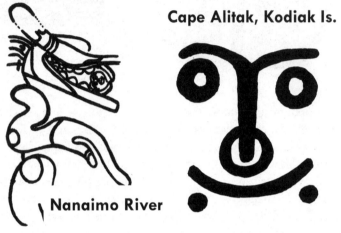

Cape Alitak, Kodiak Is.

Nanaimo River

At one site hear the Nanaimo River, heavy logging equipment was used to clear a building lot, and subsequently the removal of about a foot of soil revealed the petroglyphs on the smooth sandstone bed rock below. Some observers have estimated that about a thousand years were required for the accumulation of this depth of soil cover, but no precise study of the soil formation has yet been made.

One way in which anthropologists may make some future progress in the conundrum of petroglyph dating is by the study of changing art styles, in time and space, using carved objects precisely dated from their provenience in archaeological excavations, where the find level has been dated by the radioactive carbon method. For example, some petroglyphs of The Dalles on the Columbia River are quite similar in style to the stone and antler carvings found in association with cremation burials dated at about 1400-1800 A.D. Another example is the bone comb, two thousand years old, found in an archaeological "dig" near Prince Rupert, which is stylistically like the petroglyph animals of the park in Nanaimo.

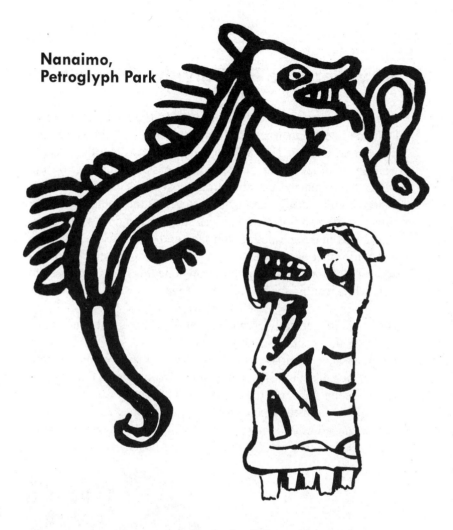

Nanaimo, Petroglyph Park

Coomb, Prince Rupert

How old are the petroglyphs? With a few recent exceptions, the age of petroglyphs is not known. Although some are comparatively recent, others may be as old as the history of men on this coast. Radiocarbon dating tells us that men were living at The Dalles on the Columbia River and at Ground Hog Bay on Glacier Bay in Alaska about ten thousand years ago. Whether any of the petroglyphs are as early as that, we do not know.

Why Were the Petroglyphs Carved?

Were some petroglyphs only doodlings? In 1952 the archaeologist Douglas Leechman was travelling by canoe with an Aboriginal friend near Seattle. They had to go ashore at Agate Point while waiting for slack water in the narrow pass. As they sat on the beach, the friend chose a stone from those at his feet went over to a large boulder nearby and began to peck at the boulder with the stone. Leechman followed and was surprised to discover that his friend was making a petroglyph face and went on to explain he had made other designs on the boulder and that his father had also pecked faces on it, and that they had done this merely to pass the time while waiting for the tide to change.

One must immediately comment that this Aboriginal is a man of our own times and that he may not have the same spiritual or religious motivation as petroglyph carvers may have had before the impact of European civilization. The carving of the petroglyphs seems generally to have ceased in the early historic period. Though some of the figures of the Agate Point petroglyph must be recognized as doodling, it would not necessarily be correct to apply this rationale to other petroglyphs. An elderly Aboriginal in-

formant from the same area has reported that when she was small she was warned by her elders not to walk in front of petroglyphs. Moreover, Dr. Buchanan of the Tulalip Indian School, travelling past this same place with Indian people in 1916, reported that they would not approach the Agate Point petroglyph boulder. The historian Hunt wrote in 1916 that the "Indians were much afraid of the same stone", and archaeologist Marian Smith reports that a Suquamish First Nations' named Sam Wilson claimed to have "put his mark on it". Looking at the Agate Point petroglyphs now, we cannot distinguish which carvings are doodling and which are the older venerated glyphs which had power and could frighten the Aboriginal people. Although some petroglyphs of the Northwest Coast may have been done merely to pass the time, this explanation is probably not satisfactory for most carvings. The evidence from the Aboriginal people themselves, recorded by archaeologists and others, the limited information in myths, and a historical incident recorded by early Hudson's Bay employees, all suggest that the prehistoric carver had a purpose and meaning in mind as he worked. Before we can understand that purpose, we must know something about the world-view of the prehistoric coastal people.

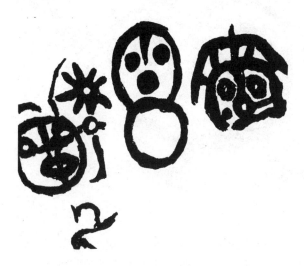

Agate Pt.

23

The Religion of the First Peoples of the Northwest Coast

Most of the petroglyphs remain where they were made. When you stand in front of them, your feet press the earth where the carver once stood and you feel the air on your face as he did. Because we cannot see into the mind that envisaged the design and directed the hand that pecked it out of the stone, we need the writings of the early ethnographers on this coast and the myths so diligently collected. They can tell us something of the world view of these coastal people.

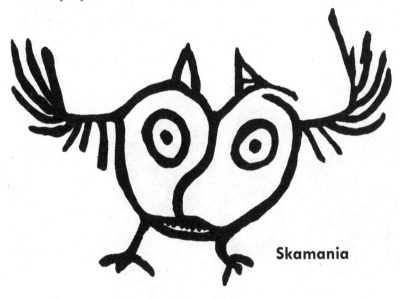

Skamania

What happened to a man after death? Did he linger nearby, jealous of the living and dangerous to them, or did he turn into an owl hooting in the forest at night? The First People of this area do not seem to have believed in a "heaven", although the myths tell of a world above, inhabited by immortals, into which certain men

have climbed. Is there a God-Creator up there? There appears to be a deity commonly linked with the sky or sun, but remote and vaguely known, and of little importance in the daily routines of life. More important to the Aboriginal People were a special class of spiritual beings who inhabited their own world of sea, forest, mountain and sky. Some of these became guardian spirits, giving power to men. Some were animal spirits or beings who took animal shapes.

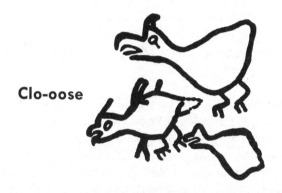

Clo-oose

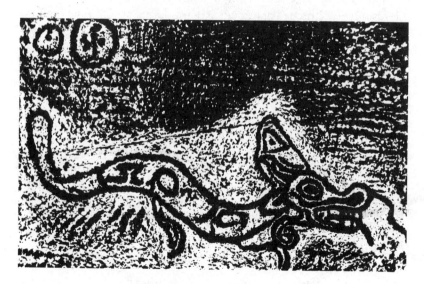

Nanaimo River

Others had a terrifying and monstrous appearance-huge birds with sharp beaks, or sea monsters. The Thunderbirds, who kept snakes like lightening which they hurled at whales, could fly with a whale clutched in their talons. The terrifying spirit beings were dangerous, but most of them could confer gifts and power too.

Of special importance were the salmon. In their homes beneath the sea, the salmon went about in human form, living in houses similar to the houses of the People. When the time came for the annual spawning migration, the salmon put on their salmon guise and swam into the streams of the coast, voluntarily sacrificing themselves for the benefit of men. The villagers believed that if the bones were put back into the sea, the fish would come to life again, to return another year.

Some petroglyphs seem to be associated with the annual return of the salmon. The anthropologist Franz Boas reported in 1890 that if the salmon did not come, the Nootkan shaman (i.e. medicine man, witch-doctor, priest) would put an image of a fish into the water in the direction from which the salmon usually returned, and would pray to the fish to come. The salmon is the basic food resource of the coastal people. It was dried to provide food all through the winter. And yet the annual return of the fish is mysterious, unpredictable. We can imagine the fishermen waiting, as the season for the return of the salmon approached, with their nets set in the streams, their weirs and spears ready, the rock walls of the fish traps waiting. E.L. Keithahn thought that the petroglyphs were placed where the tide would submerge them in order that the fish would hear the message of the carved figures.

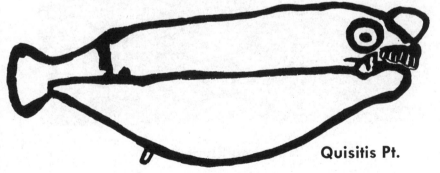

Quisitis Pt.

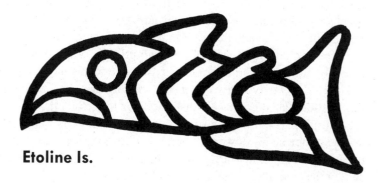

Etoline Is.

A Tlingit legend, written down in 1909, tells a story of Raven, the most important spirit figure of the Tlingit people, some times human, sometimes a bird. The tale involves a petroglyph face:

"after a while Raven came to an abandoned camp where lay a piece of jade half buried in the ground, on which some design had been pecked. This he dug up. Far out in the bay he saw a large spring salmon jumping about and wanted to get it but did not know how. Then he stuck his stone into the ground and put eagle down upon the head designed thereon. The next time the salmon jumped, he said, 'See here, spring salmon jumping out there, do you know what this green stone is saying to you? It is saying, You thing with dirt y, filthy back, you thing with dirt y, filth y gills, come ashore here.' . . . Raven made this jade talk to the salmon."

Cape Mudge

A Haida man told Keithahn that the old people said the petro-glyphs were for the purpose of causing rain. Far south in Puget Sound the Aboriginals there told an early missionary that if the Eneti petroglyph were shaken, rain would fall. When the petro-glyph boulder was found at Kulleet Bay, the locals named it the 'Rain God'. One would wonder why rain gods were needed on this rain-drenched coast: Keithahn tells us that when the salmon are returning to spawn they sometimes school up in the salt water and wait for a heavy downpour of rain before entering the streams, because the rain temporarily raises the level of water in the rivers so that they can more easily swim upstream.

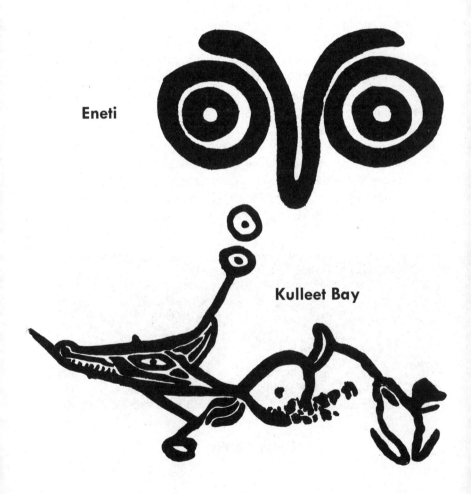

Eneti

Kulleet Bay

Another legend associating petroglyphs and salmon is the Tlingit story about a shaman named Shin-q uo-klah, or "Mouldy End". As a young man, Shin-q uo-klah forced a slave to eat a piece of mouldy salmon and throw the bones into the sea, thus enabling the fish to return to life and to his home under the sea. This act pleased the Salmon Chief, who rewarded Shin quo-klah by giving him great power. Several petroglyphs on the Alaska n coast are supposed to represent this famous shaman.

Wrangell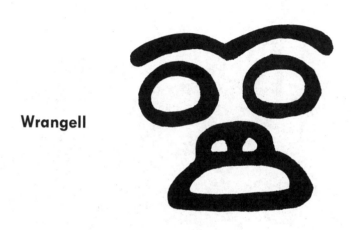

The Jack Point petroglyph in Nanaimo is associated with a myth about a dog salmon that became a human and took the shaman's daughter as his wife. In a version of the tale recorded by Barnett, the shaman's daughter went away in the sea with her salmon husband. Then her father went to the far north to search for her where the dog salmon live beyond the other salmon, but there he was told that although she could not go home with him, she and her husband would come to Nanaimo each year and would swim up the river, leaping out of the water together, and no one but the chief and his descendants should touch them. Each year the Nanaimo people could eat roasted whole dog salmon but could not cut them up for drying or smoking until the ritualist invited all of the people of the village to a ceremony at his house. There a male

and female dog salmon were painted with ochre and sprinkled with eagles' down. Then the ritualist shook his rattle and started his song over the fish and everyone joined in. After the ceremony, all villagers were free to smoke the dog salmon. If the dog salmon run was late, the ritualist painted over the Jack Point petroglyph fish with red ochre, and at the same time, he painted ochre on bits of four different substances, including goats' wool and a grass, and he burned these at the foot of the rock.

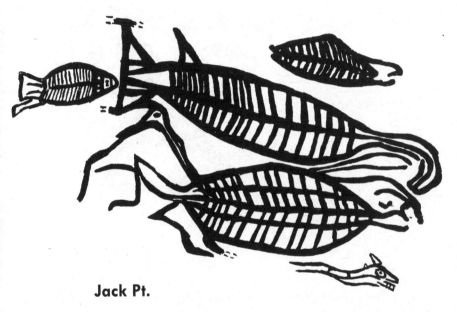

Jack Pt.

When we say that some petroglyphs were used in association with the annual return of the salmon as a way of "calling" the fish, we must look beyond the economic purpose and try to understand the underlying cultural attitudes. The Aboriginal People were a part of the world around them, a humble element in it. The spirits which share his world and sometimes take animal form are powerful. On the 5th Thule Expedition, when Knut Rasmussen was in conversation with Aua, an Eskimo shaman, Aua said to him, "We fear the souls of dead human beings and of the animals we have killed . . . the greatest peril of life lies in the fact that human food consists entirely of souls."

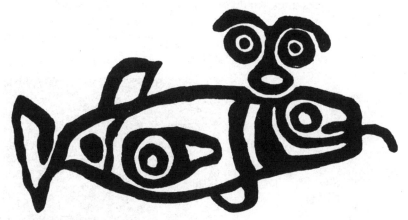

Return Channel

We must also consider why the carving of a picture in the rock gave power. Man is a symbolizing, meaning-seeking animal. The history of religion shows that man's drive to make sense out of experience, to find a meaning in life, is evidently as pressing as other biological needs. Meanings are "stored" in symbols. Symbols sum up, for those for whom they resonate, what is known about the way the world is and how one ought to behave in it. The power of the symbol comes from deep levels of the subconscious. Giedion suggests that the origin of primitive art lies in its intent to give form to the inner life of man, and that "symbolism arose from the need to give perceptible form to the imperceptible." For example, symbols could give form to the frightening difference between life and death.

In confronting the threatening world around him, man sought power from the spirits who shared this world. At puberty, he sought an encounter with the spirit world, hoping to acquire power for his adult life. In this Spirit Quest, the young person was taught to seek an isolated spot, to fast and pray, to cleanse himself ritually in the sea or lake by scrubbing his body with twigs, and to induce vomiting to be clean inside. He sang and danced to exhaustion, and finally would induce a psychedelic experience in which he saw his guardian spirit. Some groups of Interior Salish First Nations would instruct their young people to record their visions on

the rocks. They believed that by making pictures of their visions on the rocks, they would obtain more power. The image has some of the power of the spirit it represents. We are familiar with the primitive person's fear of the photograph because it steals some of the life or power of its subject.

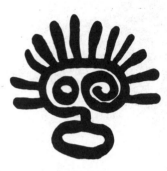

Return Channel

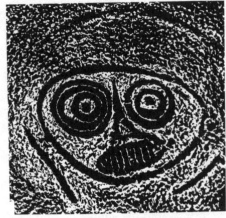

Fulford Harbour

The petroglyph art of the Northwest Coast is dominated by eyes. Keithahn tells us that spirits could be portrayed as eyes alone. What is the further meaning of the faces where the left and right eyes are different? Gutorm Gjessing finds this motif widely distributed throughout Europe, Siberia, the Pacific area, the West Indies and the northeast coast of South America. He looks at the ancient idea of the power associated with one eyed gods in mythology. Odin gave one of his eyes in exchange for wisdom and a knowledge of things to come. In an interesting parallel, a spirit with one eye named Lqwalus, in a spirit canoe ceremony in the Puget Sound area, says, "Now look at me! I have only one eye and with it I can see everything!" The widespread occurrence of this distinctive feature does not necessarily indicate anything precise in terms of the transfer of ideas or people, for motifs are more easily transferred than the ideas they represent, and there is a tendency for motifs to diffuse more readily than integrated art styles. However, the petroglyph eyes that look out at us from the rocks of the Northwest Coast probably represent the spirits of the Aboriginal world.

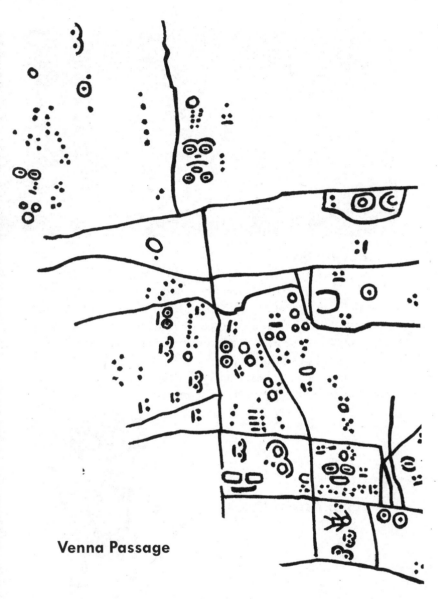

Venna Passage

At its most intense level, the search for power is associated with the shaman or medicine man. The psychological process by which shamanistic powers are acquired is poorly under stood. It would seem, however, that rigorous training or illness precedes the acquisition of power, and visions and artistic creation are a part of the process. What kind of men are shamans? Why are they

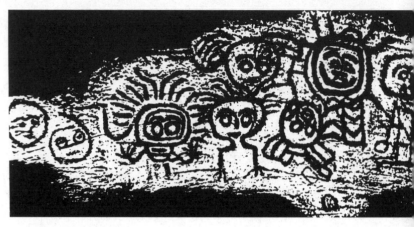

Kulleet Bay

valued? The shaman is a specially gifted person who undergoes catastrophic experience (simulated death, loss of identity, change of sex); after long training and many initiations, by performing dances and by virtue of costumes or ritual equipment, he is able to visit the world of spirits for purely religious purposes or to learn how to cure. There are many accounts in the ethnographic records of the training and experiences of shamans.

Jump Across Creek

A Gitksan shaman told Marius Barbeau that he was thirty years old when he began to be a shaman. He was in the hills getting firewood when, towards evening, a loud noise broke out over him and a large owl appeared. The owl took hold of him, caught his face, tried to lift him up. He lost consciousness. When he came to his senses he was lying in the snow, the blood running out of his

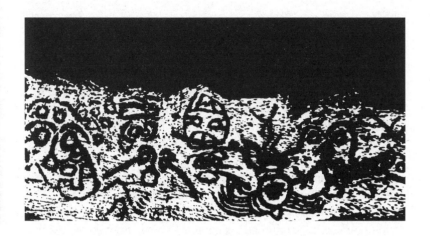

mouth. He went down the trail, and as he stumbled past, the trees seemed to shake and lean over him, and tall trees crawled after him as if they had been snakes. When he reached the village, the other shamans worked over him to bring him back to health. Later he had a second hallucinatory experience and was ill before he started the training for a shaman. Then he fasted for a year, living in isolation, and gradually acquired power. Finally he was called to cure his first patient, the wife of a chief who had been ill for many years, and his success in healing her greatly enhanced his reputation as a shaman.

Although there is no firm evidence to relate such experiences to the petroglyphs, it has been suggested that some petroglyph sites are the places where the shamans spent time in fasting and training. The Kulleet Bay pool is one petroglyph site which may have been used for this purpose.

The site is a smooth sandstone basin about fifteen feet long, six feet wide and perhaps five feet deep, in the bed of a small stream. A round the top rim of the pool is a frieze of petroglyph faces. In the spring of the year the run-off fills the pool, completely submerging the carvings. Later in the year the water has fallen to the level of a darkened band below the petroglyphs, the usual winter water level. In summer the pool is completely dry. If the petroglyphs had been made in summer, the carver would have had a large expanse of smooth sandstone on which to work. But

since the pictures are precisely carved along the narrow rim above the band of the winter water level (and unless they were carved upside down, which seems unlikely), it would seem probable that they were made by a person partly submerged in the cold water of the pool. The use of pools for ritual cleansing during training in the Spirit Quest is well documented. When this petroglyph site was discovered in 1931, the Chief of the Kulleet Bay people said that the petroglyphs were probably carved by shamans during their training. The Alaskan archaeologist de Laguna was told that some rock paintings were made by people training to be shamans and that some figures represented the "familiars" of shamans. It is not surprising that we know less about the association of shamans with their secret training places than we know about the shamans' roles in fishing ceremonies, for the shaman's experience was a very private ordeal occurring in a secret place, whereas the ceremonial was a public affair involving the entire band.

An early anthropologist, C.F. Newcombe, suggested that the Sproat Lake petroglyph carvings had something to do with the prolonged period of solitary training of the candidates for ad mission to secret societies "during which they sometimes had to illustrate, as well as they were able, the spirits with which they held communion."

Sproat Lake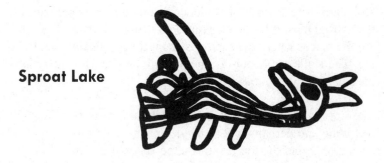

The Bella Coola people told McIlwraith that the Tastsquam petroglyph site near Bella Coola was the meeting place for a secret organization, and that an uninitiated person would have been

killed for trespassing there. Smith was told that the Bella Coola petroglyphs were carved by a family while secretly singing sacred songs, pecking in time to the music. This information seems to relate to Newcombe's statement that, those seeking spirit powers, made pictures of "the spirits with which they held communion."

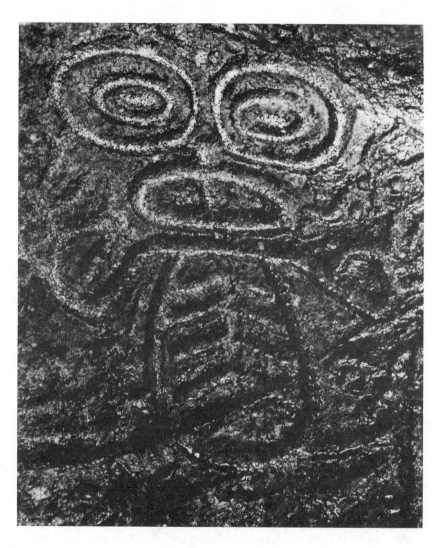

Thorsen Creek

From the writings of Franz Boas comes an account of the killing of a slave at Fort Rupert, witnessed by two Hudson's Bay employees at the trading post. Only the stone chimney now remains to mark the Hudson's Bay Fort from which Mr. Moffat and Mr. Hunt watched a slave, a man of the Nanaimo "tribe", run down to the beach where he was shot. The dancers of the secret societies followed. The body was cut and the hamatsas squatted down, dancing and crying, "Hap! hap!" "Then the bear dancers took up the flesh and, holding it like bears and growling at the same time, they gave it to the highest hamatsa first and then to the others. In memory of this event a face . . . was carved in the rock on the beach at the place where the slave had been eaten." The hamatsa ceremony is a re-enactment of the taming of the wild animal aspect of man, and though it begins with the hamatsa as a maddened cannibal, it ends with the hamatsa emerging as a proud and civilized member of the most powerful society of the band. One of the Fort Rupert petroglyphs was carved in association with this ceremony, but what is the meaning of the petroglyph face? Boas says it represents a spirit, but it is difficult to understand the full meaning of this.

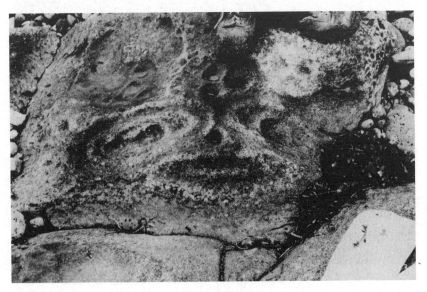

Fort Rupert

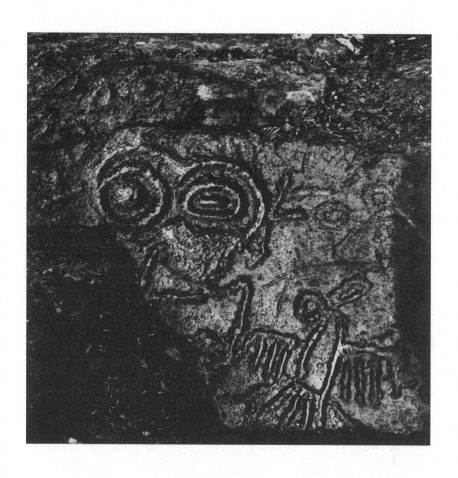

Thorsen Creek

Some Tlingit people told de Laguna that petroglyphs were some-
times made as a record of slaves sacrificed at potlatches. A Cape
Mudge First Nations pointed out a boulder with a petroglyph on
it which he said was the place where prisoners were killed. From
Bella Coola, McIlwraith recorded the information that if a chief
gave an important ceremony, he or one of his friends carved a
petroglyph of a man or of an animal connected with the ceremony,
to recall the event. McIlwraith adds that as no carvings have been
made within the lifetime of any living person, there may have
been a further significance, no longer known.

A Bella Coola First Nations identified certain petroglyphs at No-eick River as specific mythological animals and we must consider the possible function of petroglyphs in the recording of myths. The best example of this is the petroglyph Emmons saw in 1888 at Baranof Island in Alaska.

Noeick R.

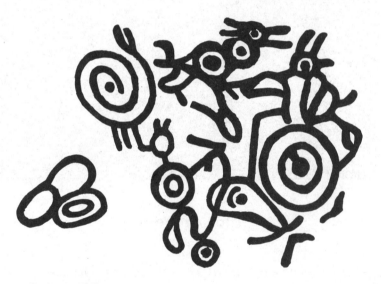

Baranof Is.

A very old First Nations Chief showed him a hidden carved rock near the mouth of a stream, a short distance above the high-tide mark. He saw a picture made up of five principal figures, which told the story of the creation of the world. The legend, well known on the Northwest Coast, tells that the world in the beginning was a dark chaos, but a spirit known as Yehlh,who had many forms

but often appeared as a raven, created man, and wrested light, fresh water and fire from the other spirits to give these blessings to man, and who then governed the winds for man's benefit. The petroglyph panel shows Yehlh in bird form. There is a spiral which Emmons' interpreter named "where the sunlight comes from". The bill of the raven holds a stick-like form which could be the fire Yehlh stole from the sun. Joined with the raven is a figure made of three concentric circles which represents the earth. Directly above is a form identified as Hoon, the North Wind. The last figure is Kun-nook, the guardian of fresh water, frequently represented as a wolf, from whom Yehlh stole fresh water.

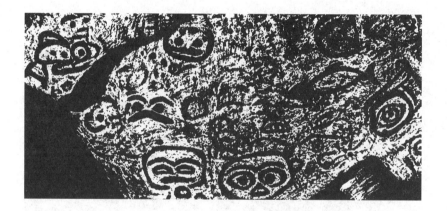

Observatory Inlet

The mythological animal who was the ancestor of the group became a crest symbol, and these were sometimes used to mark boundaries. The Coast Salish told H.I. Smith that petroglyphs were carved to mark the boundaries of family hunting territories, but we do not know which petroglyphs were referred to in this remark. The Observatory Inlet petroglyph now on display outside the Prince Rupert Museum was said to have been carved to mark hunting territory. In MEN OF MEDEEK, Walter Wright of the Kitselas people tells how Neas Waias put his painted mark on the place to which he would return to make a new village.

In the Baranof Island legend, above, we mentioned Kun-nook, the guardian of fresh water, who was frequently shown in his wolf form. At Dogfish Bay on Quadra Island, a petroglyph called the "sea-wolf" was said by the First Nations of this island to have been carved to mark the site of the fresh-water spring nearby. The petroglyph at Malcolm Island is on top of a spring,' hidden now under the pebble beach. Whether the petroglyphs were carved to "mark" the springs, or whether there is a deeper meaning in this association, we do not know.

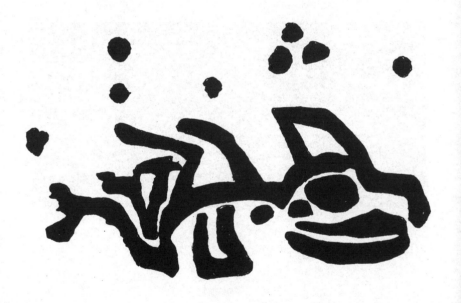

Dogfish Bay

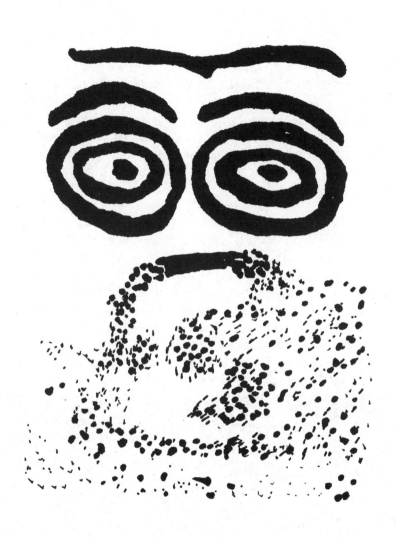

Malcolm Is.

"Possibly" . . . *"Probably"* . . . *"Perhaps"* . . .

These words frequently occur when we talk about the meaning of the petroglyphs. What we must try to understand, when we stand before the petroglyphs, is the world-view of the people who made them. Basic in these considerations is their perception of the underlying unity of the human animal and the rest of the universe. For us, modern technology has obscured this reality. In our limited modern view, ecology involves only the physical or biological phenomena. Frank Waters teaches us that for the First Nations, aspects of nature are manifestations of spiritual powers. Waters tells us to "listen to the voice of the secret and invisible spirit of the land itself."

Grahame Clark observes that "the idea that because archaeology depends on material traces it must be limited in its reconstructions to the material aspects of prehistoric life is, as we have already seen, fallacious . . . religion is reflected in the graphic arts, of which indeed it was commonly the main if not the only inspiration". With respect and reverence we have recorded the petroglyphs which express the spiritual attitudes of the First Peoples of the Northwest. We appeal to our readers to recognize the petroglyphs as a priceless inheritance and to help enforce the laws that protect them from desecration and vandalism.

Clo-oose

44

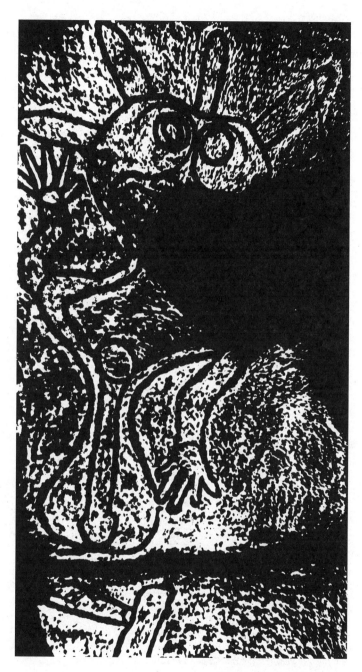

Nanaimo River

Editors note:

Then and Now....Over the years many First Nations have taken back their traditional names for their respective territories . This book was originally written in 1975 so many of these "old" names are referenced throughout.

We have compiled below a limited list to illustrate some of these changes.

People	Have been called
Dunne-za	Beaver
Nuxalk	Bella Coola
Dakelh	Carrier
Wet'suwet'en	Carrier
Tsilhqot'in	Chilcotin
Coast Salish (General) Klahoose Homalco Sliammon Sechelth Squamish Halq'emeylem Ostlq'emeylem, Hul'qumi'num, Pentlatch, Straits	Coast Salish
Haida	Haida
Kaska	Kaska
Haisla	Kitimat
Ktunaxa	Kootenay
Oweekeno	Kwakiutl
Kwakwaka'wakw	Kwakiutl
Esbataottine Tagish Takutine Titshotina Pelly River Indians	Nahani
Nuu-chah-nulth	Nootka
Sekani	Sekani
Secwepemc	Shuswap/Interior Salish
Dene-thah	Slave(y)
Tahltan	Tahltan
Tsimshian	Tsimshian
Gitxsan	Tsimshian
Nisga'a	Tsimshian
Tlingit	Tlingit

**the information was compiled from researching several websites including Wikipedia, Indigenous Foundations Arts of University of B.C., First Peoples of Canada and the Canadian Encyclopedia*

INDEX

Agate Point — 22,23

Baranof Island — 40,42

Barbeau, M. — 34

Barnett, H.G. — 29

Beaver, steamship — 17

Bella Coola — 36,37,39,40,46

Boas, F. — 26,38

Bronze Age petroglyph — 8

Buchanan, Dr. — 23

Cape Alitak — 20

Cape Mudge — 27,39

Clark, G. — 44

Clo-oose — 25,44

Columbia River — 7,8,9,10,21

de Laguna, F. — 36,39

Dogfish Bay — 42

Douglas Channel — 19

Emmons, G.T. — 40,41

Eneti — 28

Englishman River — 16

Etoline Island — 27

Fort Rupert — 17,38

Fulford Harbour — 32

Giedion, S. — 31

Gitksan — 34

Cjessing, G. — 32

Glacier Bay — 21

Ground Hog Bay — 21

Haida — 28,46

Hawaiian petroglyph — 8

Helen Point — 19

Hoon — 41

Hudson's Bay Company — 17,38

Jack Point — 9,29,30

Jump Across Creek — 34

Keithahn, E.L. — 26,28,32

Kitselas — 41

Kodiak Island — 8,20

Kulleet Bay — 28,34,35,36

Kun-nook — 41,42

Labrets — 19

Lake Celilo — 9

Laws to protect petroglyphs — 12,13

Leechman, D. — 23

McIlwraith, T.F. — 36,39

Malcolm Island — 42,43

Maps — 9,10

Maryhill Museum — 9

Myers Passage — 15

Nanaimo — 9,29

Nanaimo River — 4,20,25,45

Neas Waias — 41

Newcombe, C.F. — 36,37

Noeick River — 40

Nootka — 26,46

Observatory Inlet — 41

Olympia — 9

Otter Point — 7

Pachena Point — 6

Paleolithic art — 8

Parksville — 16

Petroglyph Canyon — 7

Petroglyph Park — 9

Port Alberni — 9

Port Neville — 5

Prince Rupert — 20,41

Puget Sound — 28

Quadra Island — 42

Quisitis Point — 26

Rasmussen, K. — 30

Raven — 27,40,41

Return Channel — 31,32

Ritualist — 29,30

Salmon — 26-30

Seattle — 22

Shaman — 30,33-36

Shin-quo-klah — 29

Skamania — 24

Smith, H. — 37,41

Smith, M. — 23

Spirit quest — 31,36

Sproat Lake — 9,36

Suquamish — 23

The Dalles — 7,9,14,20,21

Tastsquam Creek — 36

Thorsen Creek — 37,39

Tlingit — 27,29,39,46

Tulalip Indian School — 23

Tumwater Falls Park — 9

Venn Passage — 33

Waters, F. — 44

Wilson, S. — 23

Wrangell — 29

Wright, W. — 41

Yehlh — 40,41

ADDITIONAL HANCOCK HOUSE TITLES

MORE GREAT CULTURAL READS!

Ah Mo
Tren Griffin
ISBN 0-88839-244-3

More Ah Mo
Tren Griffin
ISBN 0-88839-303-2

Art of the Totem
Marius Barbeau
ISBN 0-88839-618-X

Native Rock Carvings
Beth Hill
ISBN 0-919654-34-7

Coast Salish
Reg Ashwell, David Hancock
ISBN 0-88839-620-1

NW Native Art-Basic Forms
Robert E. Stanley
ISBN 0-88839-506-1

Haida
Leslie Drew, David Hancock
ISBN 0-88839-621-X

NW Native Art-Creative C1
Robert E. Stanley
ISBN 0-88839-532-9

Indian Tribes of the NW
Reg Ashwell, David Hancock
ISBN 0-88839-619-8

Tlingit
David Hancock
ISBN 0-88839-530-2

Indian Herbs (Guide to)
Ray Stark
ISBN 0-88839-077-7

Totem Tales
E.C. (Ted) Myers
ISBN 0-88839-468-3

QUICK ORDER FORM
Satisfaction guaranteed

Email orders: sales@HancockHouse.com
Telephone orders: Call 1-800-938-1114
Have your credit card ready.
Fax orders: 1-800-983-2262 - Send this form.
Please send the following Books _____

See our web site for FREE information other books, authors and to join our mailing list. **www.HancockHouse.com**
Name: _____
Address:_____
City, State/Province, Postal/Zip Code _____
Country:_____
Tel:_____
Email:_____
Sales tax: In Canada add 5% tax
Payment: . Cheque, Credit card: Visa, MasterCard
Card number:_____
Name on card:_____
Exp. date:_____

48